Pam,

To my sister, my friend.

I know you will find this
book as inspirational
as I have.

Love,

Linda

# Quotable Women

# Quotable Women

## A Celebration

COURAGE BOOKS

AN IMPRINT OF RUNNING PRESS
PHILADELPHIA • LONDON

Designed by Corinda Cook
Edited by Molly Jay
Photos researched by Susan Oyama

This book may be ordered by mail from the publisher.
*But try your bookstore first!*

Published by Courage Books, an imprint of
Running Press Book Publishers
125 South Twenty-second Street
Philadelphia, Pennsylvania 19103-4399

Visit us on the web!
www.runningpress.com

# Contents

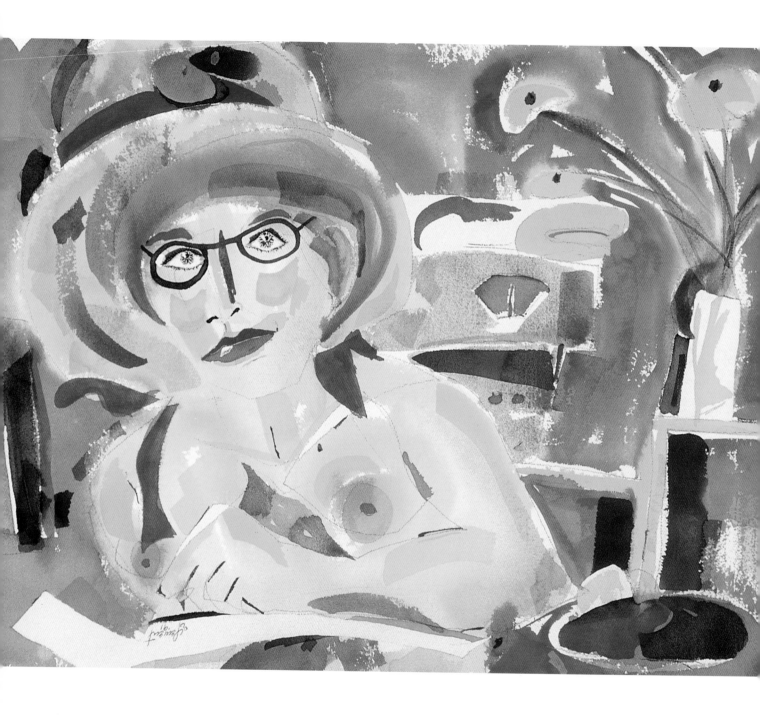

# *Introduction*

They have been at some time in the limelight, have had flair and acuity, a nimble tongue, been able to pinpoint a prodigious notion in a few words, and they've done it with exuberance and certitude.

The book you hold is a distillation of thought and reflection from some of the most distinguished female minds, past and present. At once witty, poignant, insightful and touching, the women gathered here speak freely on passion, self-esteem, endurance, secrets, and every other aspect of the human condition that connects us as kindred spirits. Rich illustration by noted female artists compliment each page of wisdom. Each intuition illuminates the next, and these diverse meetings of the mind affirm the universal quality of our experiences.

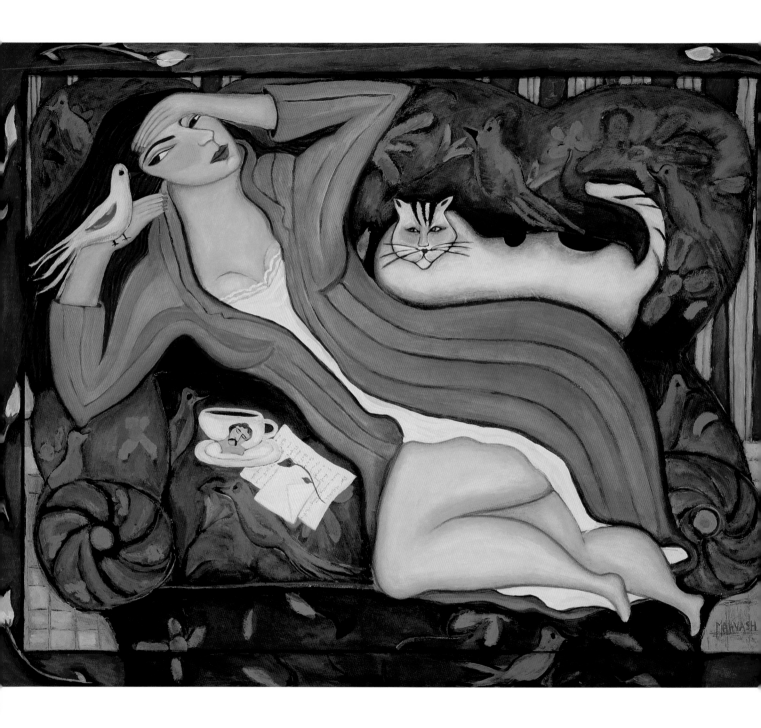

# Being a Woman

When she stopped conforming to the

conventional picture of femininity

she finally began to enjoy being a woman.

Betty Friedan

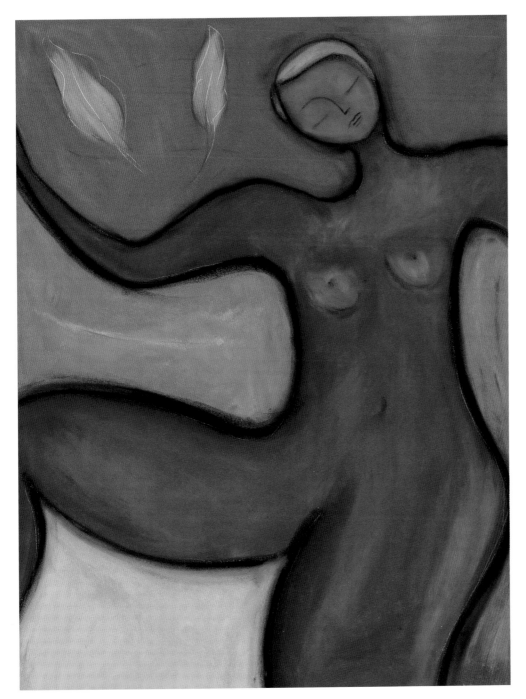

I feel there

is something

unexplored

about a woman

that only a

woman can

explore…

Georgia O'Keeffe

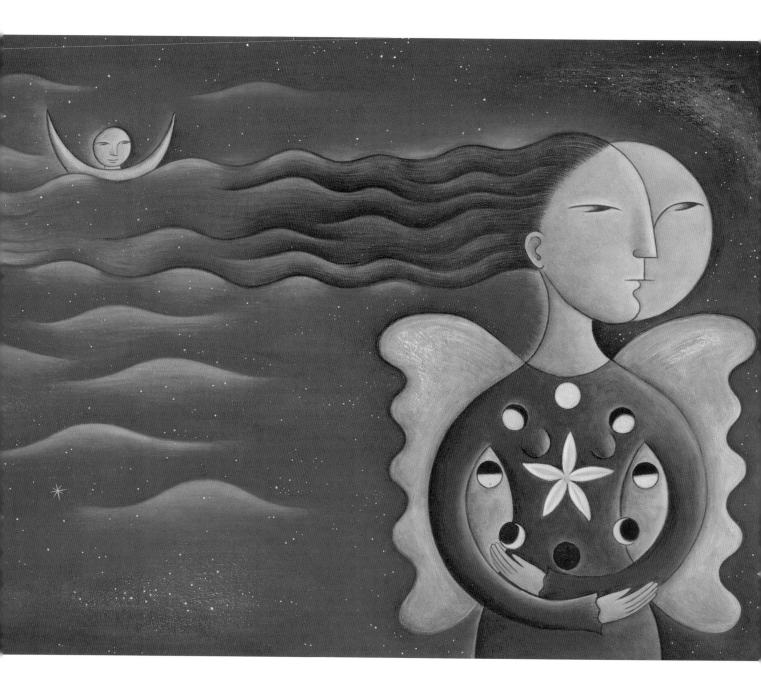

A woman is the full circle.
Within her is the power to create,
nurture, and transform.
A woman knows that nothing
can come to fruition without light.
Let us call upon woman's voice
and woman's heart to guide us in this
age of planetary transformation.

Diane Mariechild

*I never had to become*
*a feminist;*
*I was born liberated.*

Grace Slick

One is not born a woman,
one becomes one.

Simone de Beauvoir

The especial genius of women
I believe to be electrical in movement,
intuitive in function, spiritual in tendency.

Margaret Fuller

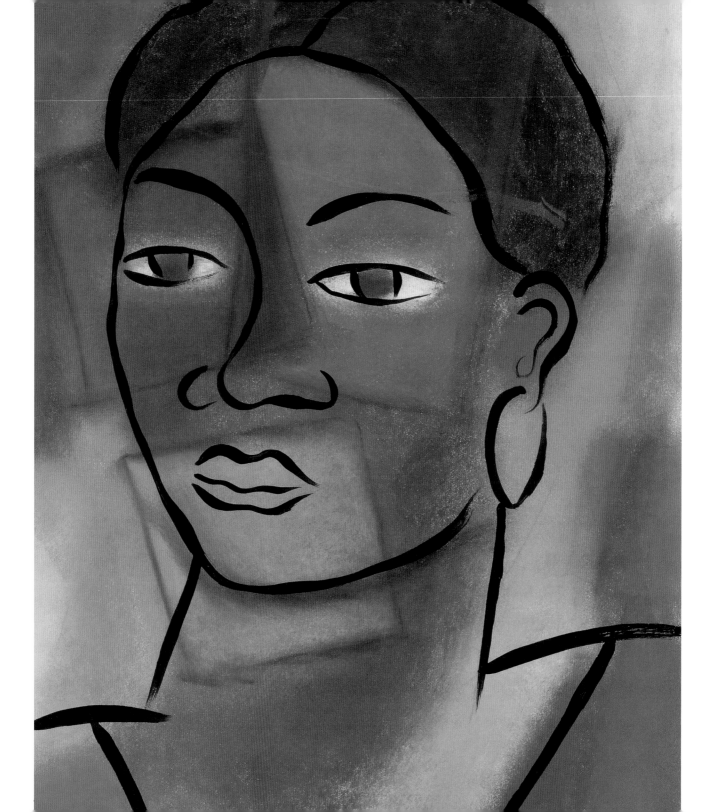

A woman can do anything. She can be traditionally feminine and that's all right; she can work, she can stay at home; she can be aggressive, she can be passive; she can be anyway she wants with a man. But whenever there are the kinds of choices there are today, unless you have some solid base, life can be frightening.

Barbara Walters

A woman may develop wrinkles
and cellulite, lose her waistline,
her bustline, her ability to bear
a child, even her sense of humor,
but none of that implies a loss
of her sexuality, her femininity...

Barbara Gordon

*W*omen are never what they
seem to be.
There is the woman
you see and
the woman who is hidden.

Erma Bombeck

*She had always
been too wise
to tell him all she
thought and felt,
knowing by some
intuition of her own
womanhood that
no man wants
to know everything
of any woman.*

Pearl S. Buck

18

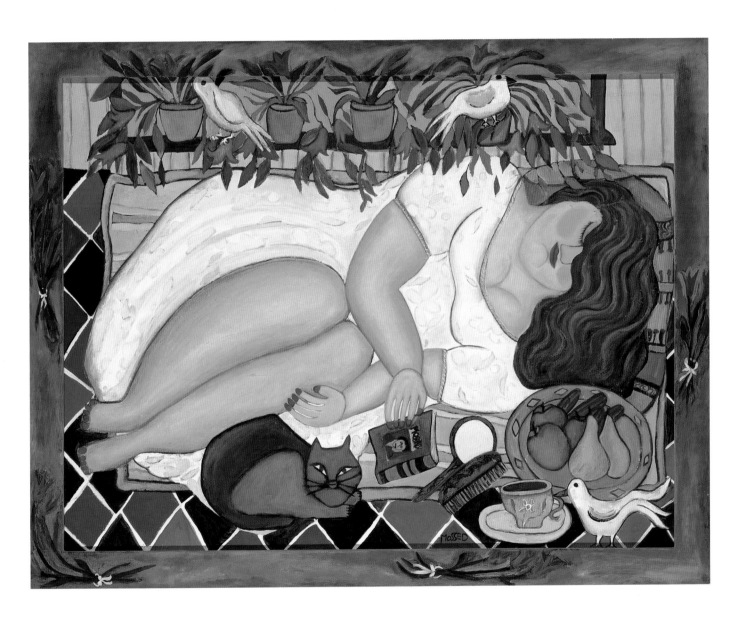

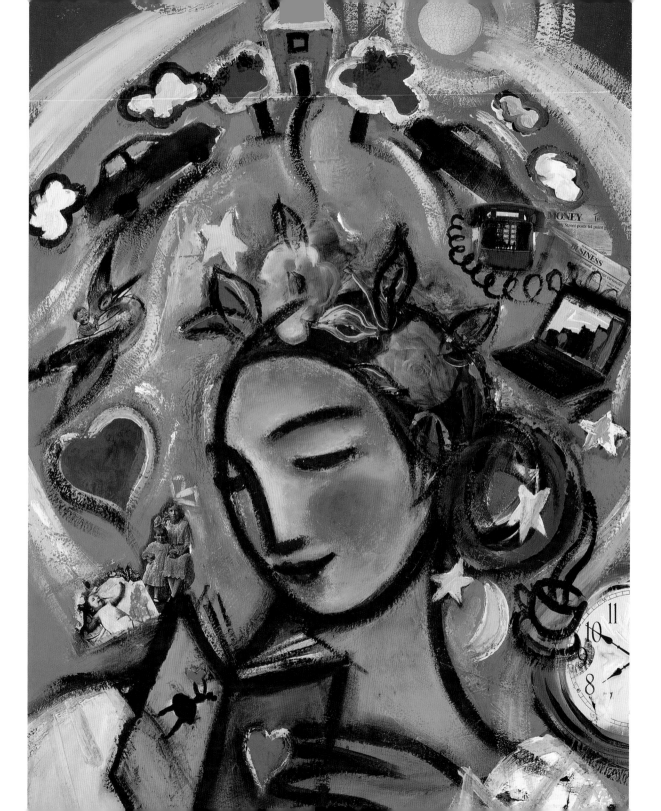

# Ambition and Challenge

*Women have been called queens*
*for a long time,*
*but the kingdom given them*
*isn't worth ruling.*

Louisa May Alcott

None of us suddenly

becomes something overnight.

The preparations have

been in the making for a lifetime.

Gail Godwin

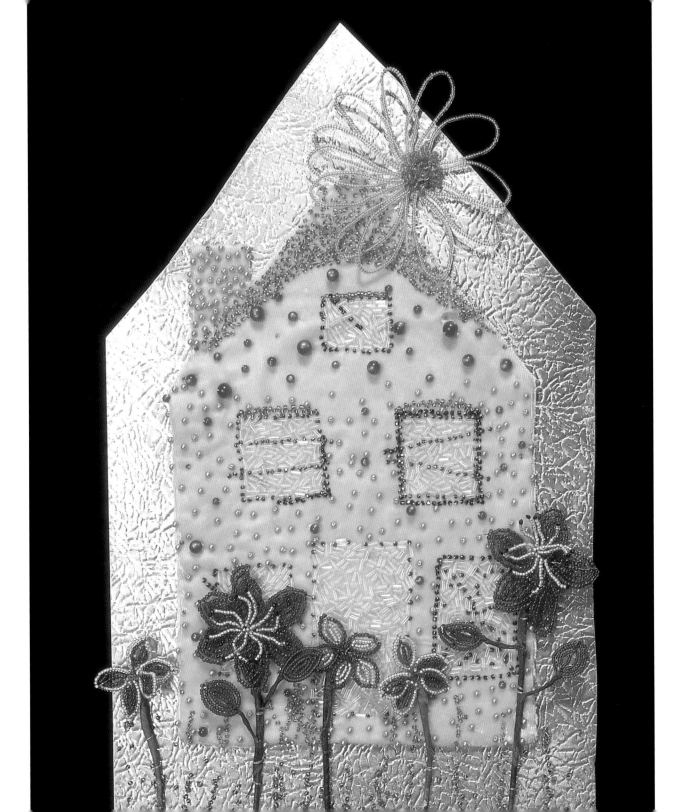

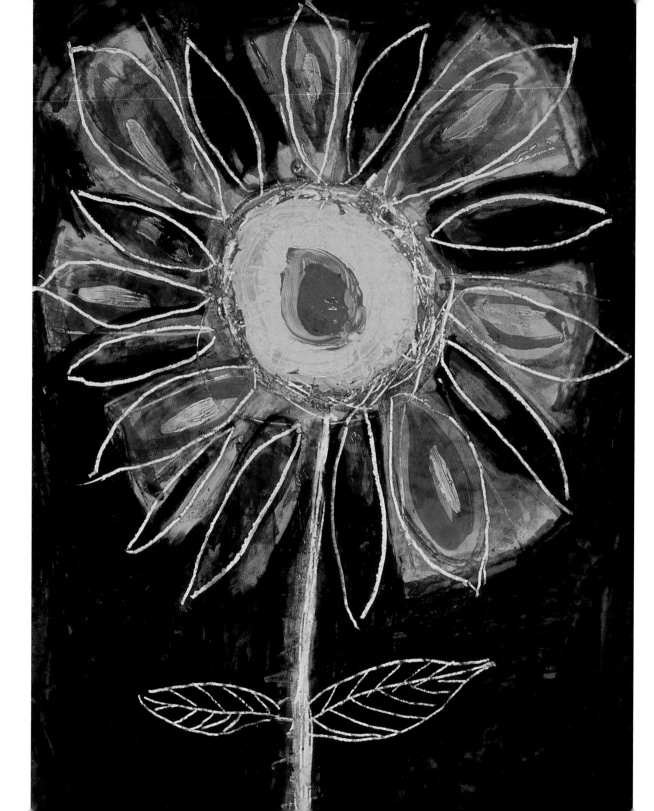

A woman's life can really be a succession of lives, each revolving around some emotionally compelling situation or challenge, and each marked off by some intense experience.

Wallis Simpson

The challenge now is to practice politics as the art of making what appears to be impossible, possible.

Hillary Rodham Clinton

*We all live in suspense,*

*from day to day, from hour to hour;*

*in other words,*

*we are the hero of our own story.*

Mary McCarthy

 feel very adventurous.

There are so many doors to be opened,

and I'm not afraid to look behind them.

———————— Elizabeth Taylor

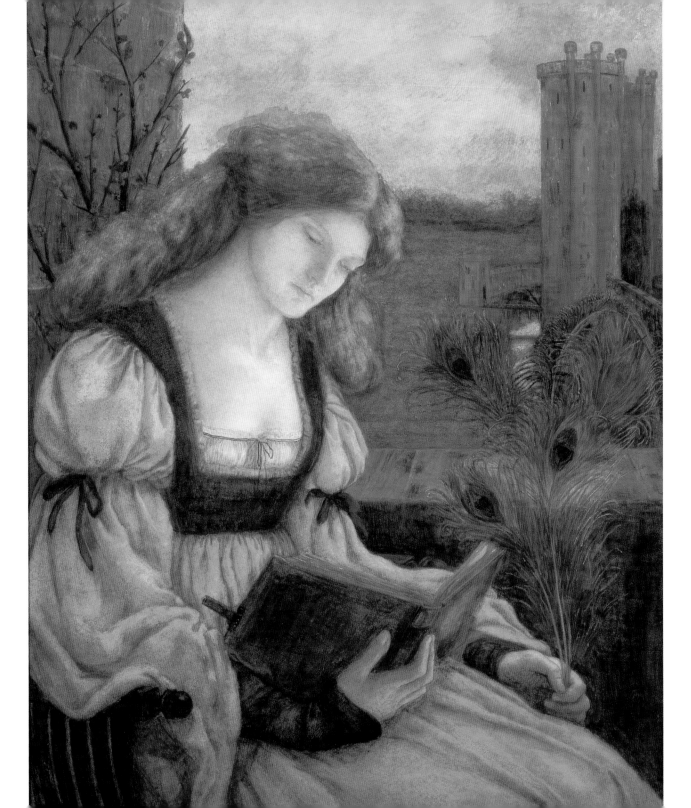

It's hard
to stay
committed...
to stay in
touch with
the goal
without saying
there's some-
thing wrong
with myself,
my goal,
the world.

Nancy Hogshead

*We have only
one real shot at liberation,
and that is to
emancipate ourselves from within.*

Colette Dowling

I've **always** tried to go a step **past** wherever people **expected** me to end up.

Beverly Sills

Prejudices, it is well known,

are most difficult to eradicate from the heart whose

soil has never been loosened

or fertilized by education: they grow there,

firm as weeds among stones.

Charlotte Brontë

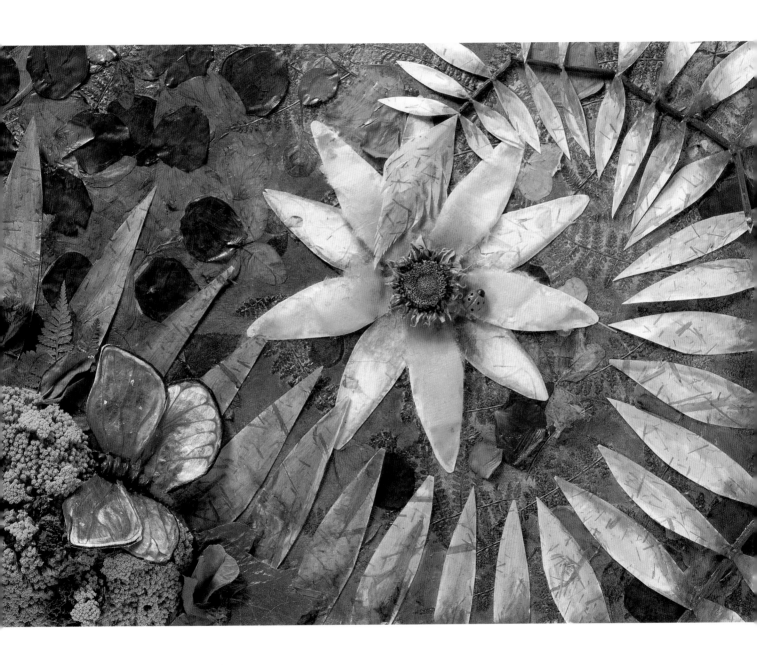

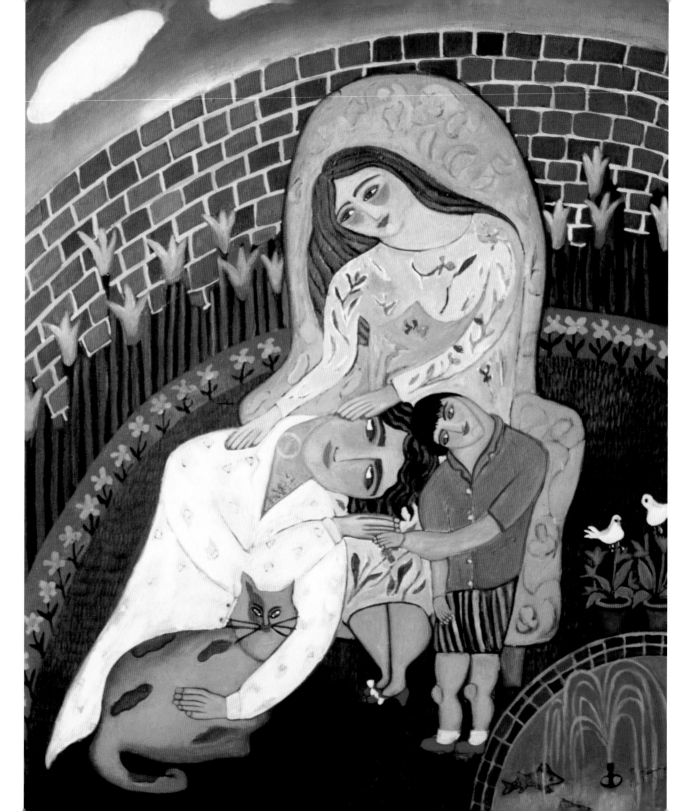

# Love and Relations

I don't need a man to rectify my existence.
The most profound relationship
we'll ever have is the one with ourselves.

**Shirley MacLaine**

# Joy is a net of love by which you can catch souls.

—— Mother Teresa

*It bugs me to have people who are obsequious.*
*If someone's humoring or manipulative, I won't have it.*
*The truth I can handle. I can't handle*
*not knowing what they're thinking or feeling.*

**Jodie Foster**

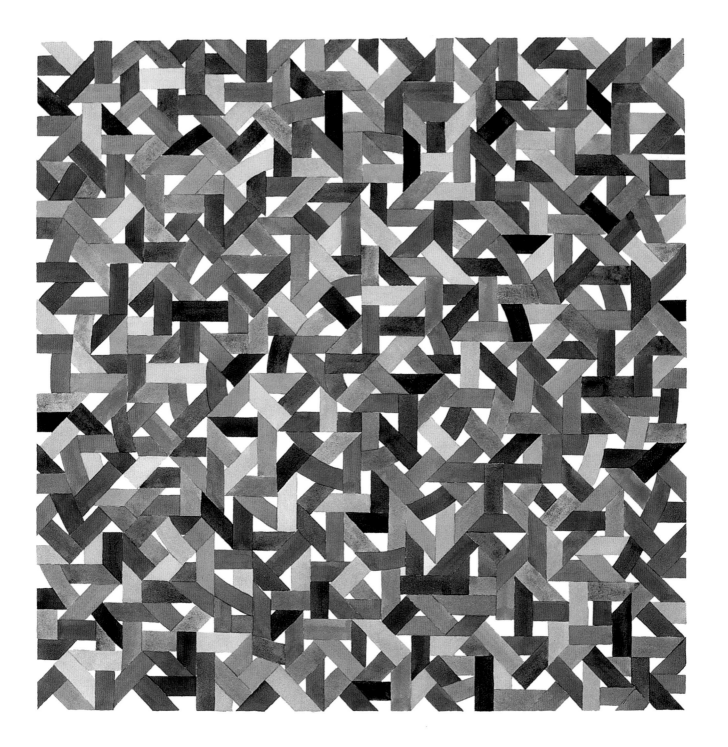

The Eskimo has fifty-two names for snow

because it is important to them;

there ought to be as many for love.

Margaret Atwood

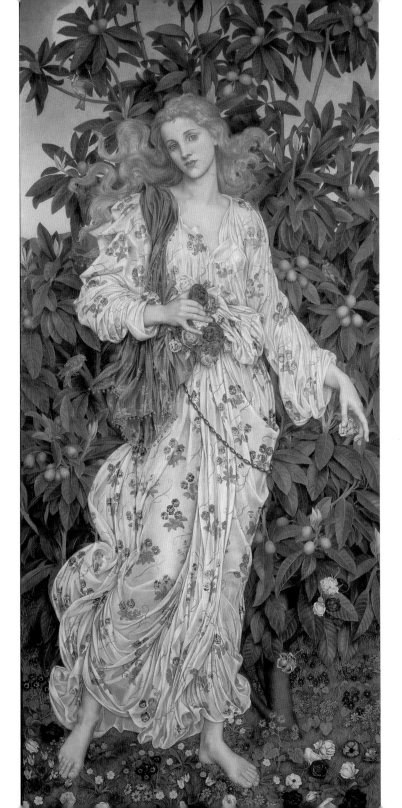

The more
I wonder...
the more
I love.

*Alice Walker*

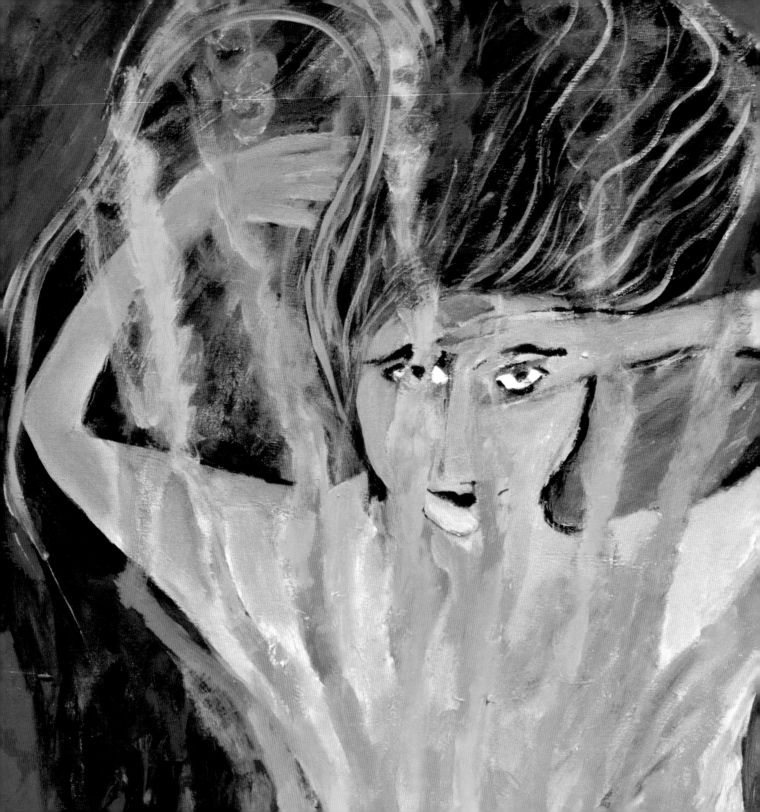

*We measure success and depth by length of time, but it is possible to have a deep relationship that doesn't always stay the same.*

Barbara Hershey

Love is a fire. But whether it is going to warm your heart or burn down your house, you can never tell.

Joan Crawford

*Marriage* is not just spiritual

communion and passionate embraces;

marriage is also three meals a day,

sharing the workload and

remembering to carry out the trash.

Dr. Joyce Brothers

Chains

do not

hold a

marriage

together.

It is threads,

hundreds

of tiny

threads,

which sew

people

together

through

the years.

Simone Signoret

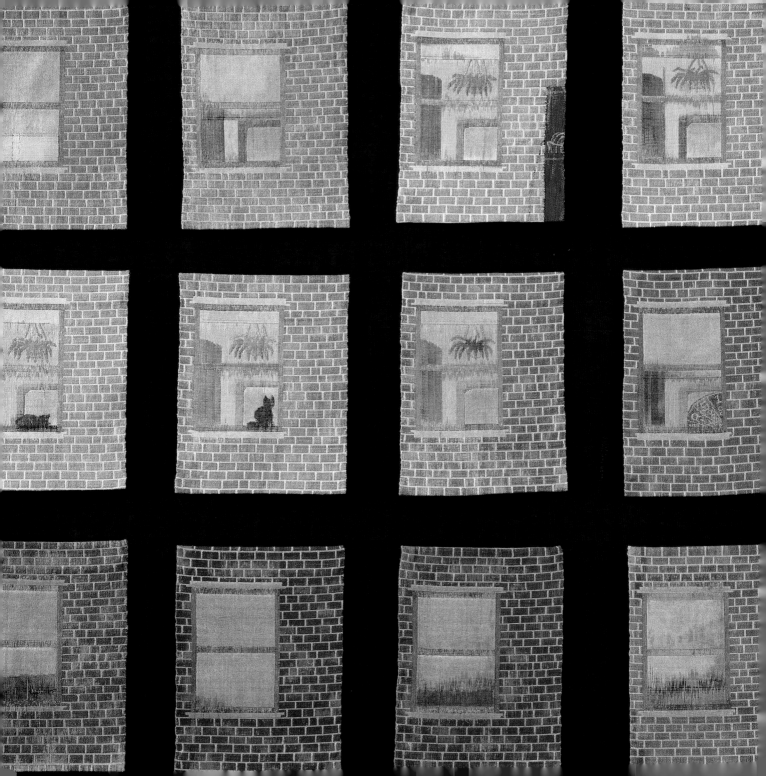

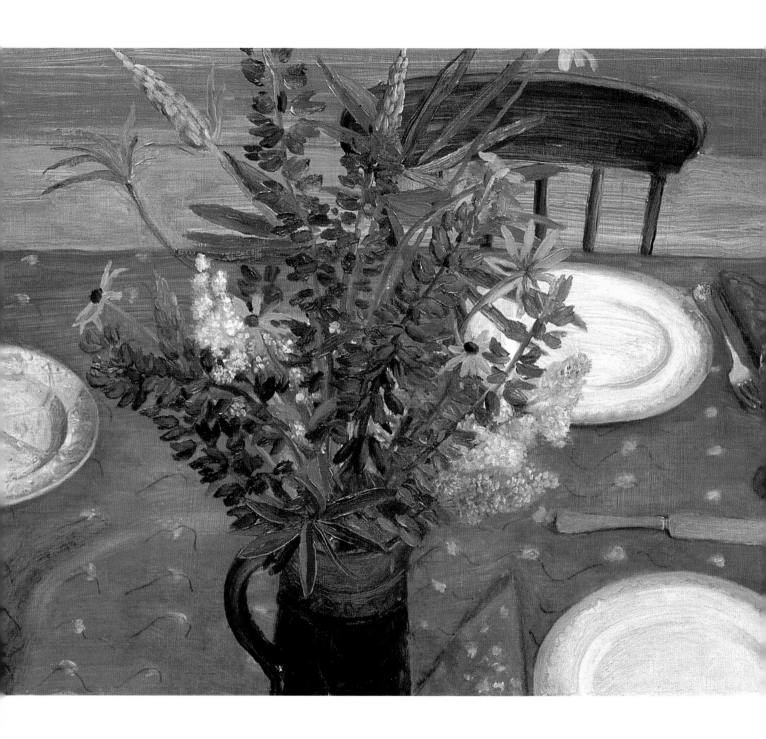

...Love from one being to another

can only be that two solitudes

come nearer, recognize and protect

and comfort each other.

Han Suyin

*I'd rather have roses on my table than diamonds on my neck.*

Emma Goldman

Do not seek the because—in love there is no because, no reason, no explanation, no solutions.

Anaïs Nin

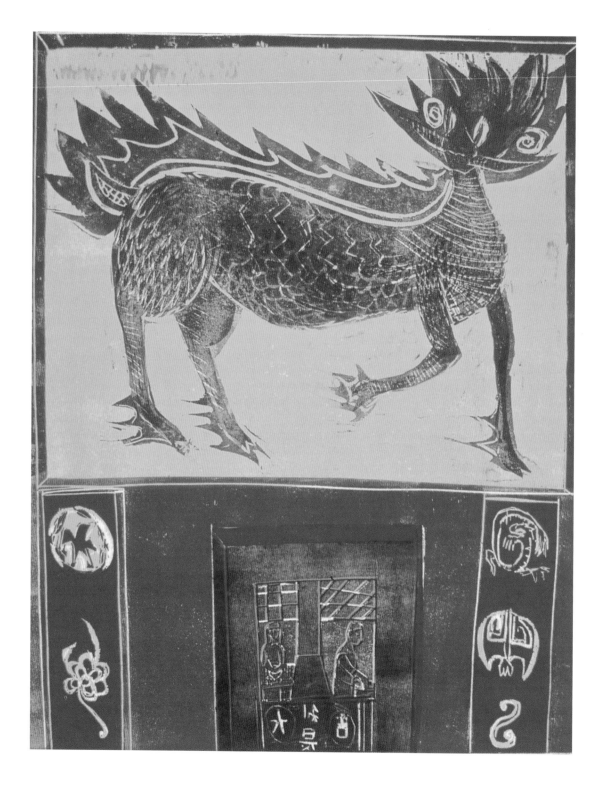

# Creativity

# Creativity can be described as letting go of certainties.

Gail Sheehy

*Original thought is like original sin:*
*both happened before*
*you were born to people you could*
*not possibly have met.*

Fran Lebowitz

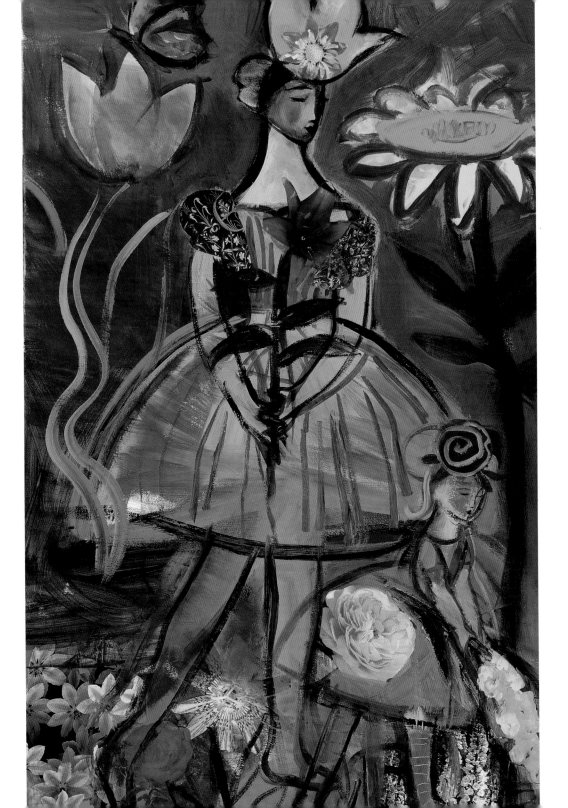

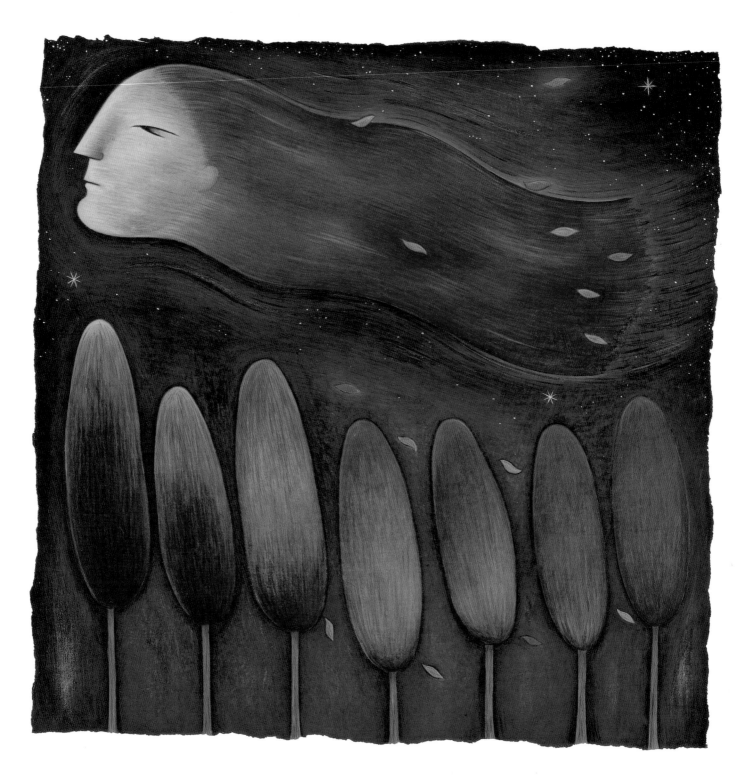

It is wonderful to be in on the creation of something, see it used, and then walk away and smile at it.

Lady Bird Johnson

*The excitement, the true excitement,
was always in starting again.
Nothing's worse than an accomplished task,
a realized dream.*

Marilyn Harris

...the artist

is not there to

be at

one with the

world, he

is there to

transform it.

Anaïs Nin

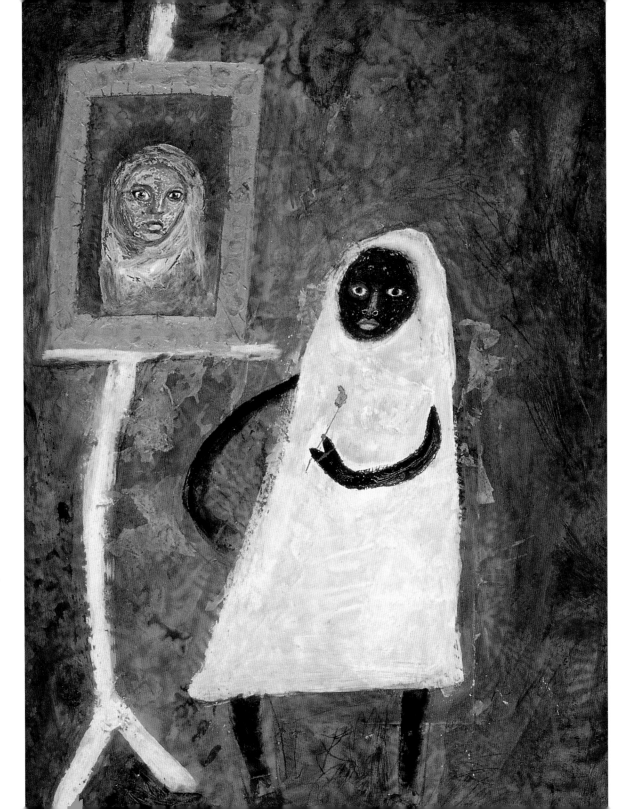

*Some of us come on earth seeing—some of us come on earth seeing color.*

Louise Nevelson

*Imagination is the highest kite one can fly.*

Lauren Bacall

One wonders what would happen

in a society in which

there were no rules to break.

Doubtless everyone

would quickly die of boredom.

Susan Howatch

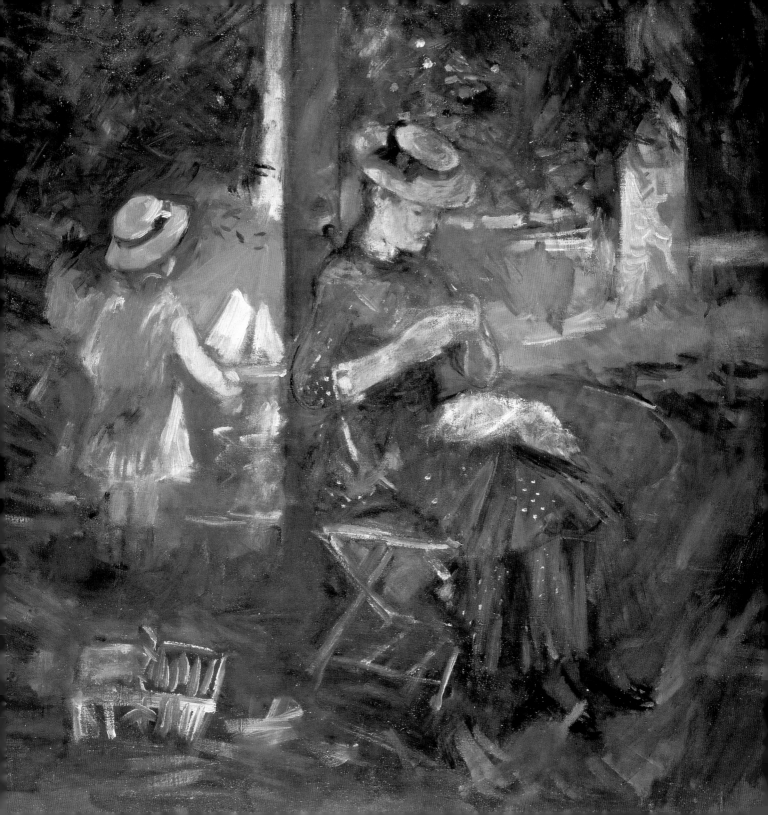

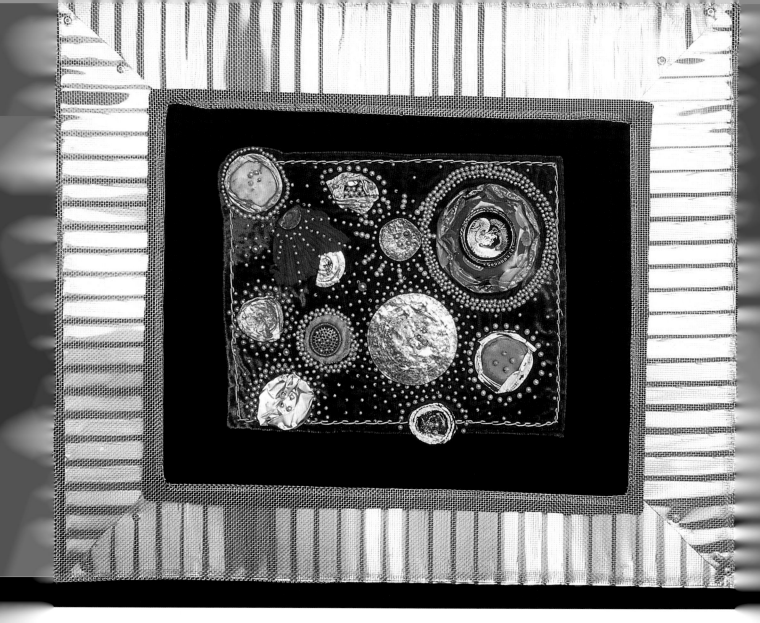

All prosperity begins in the mind and is dependent
only upon the full use of our creative imagination.

**Ruth Ross**

# Creative minds have always been known to survive any kind of bad training.

Anna Freud

Talent is like electricity. We don't understand electricity. We use it. You can plug into it and light up a lamp, keep a heart pump going, light a cathedral, or you can electrocute a person with it.

Maya Angelou

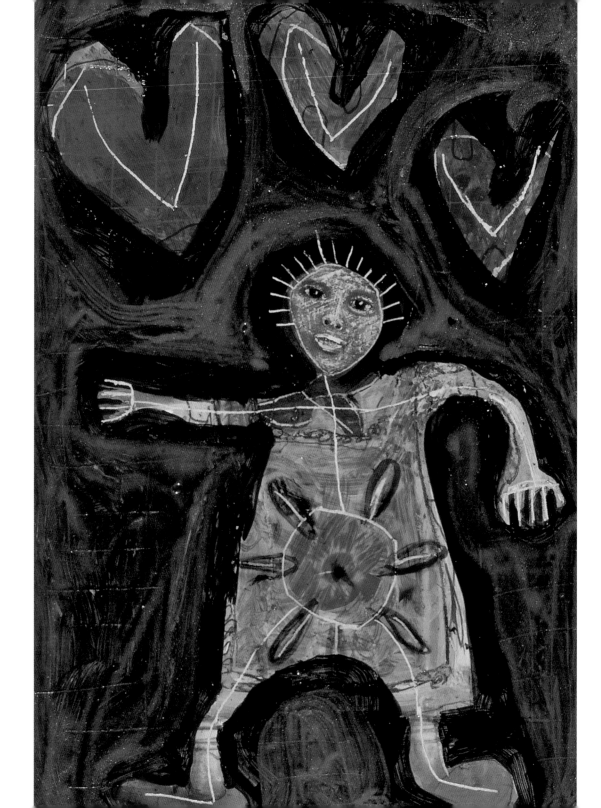

# Joy

There is a **vitality,**

a life force,

an **energy**

that is translated

through **you;**

and because

there is only **one**

**of you** in

all of time,

this expression

is **unique.**

Martha Graham

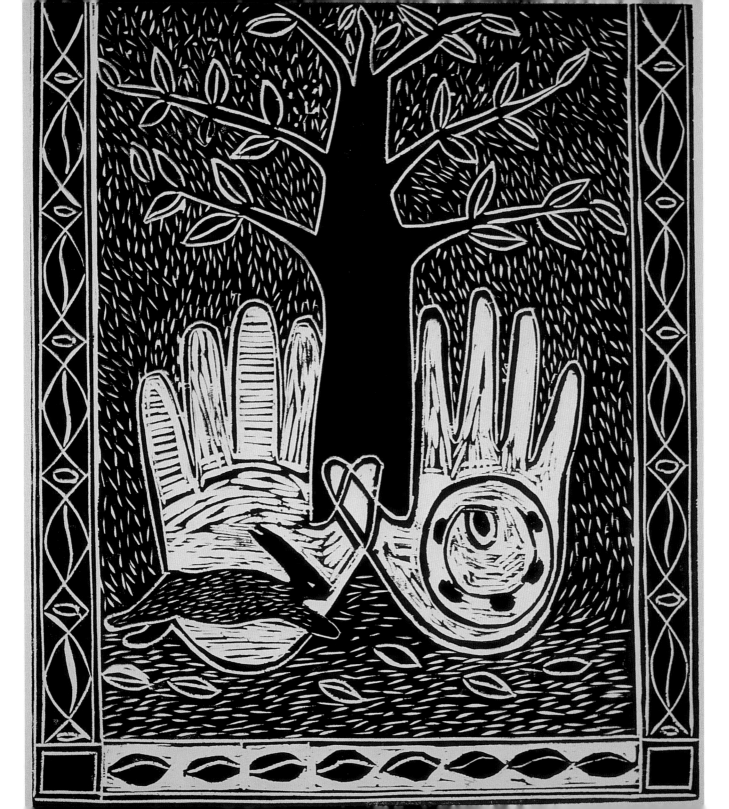

The real things haven't changed.

It is still best to be **honest** and *truthful;*

to make the most of what we have;

to be happy with **simple pleasures;**

and have **COURAGE** when things go wrong.

Laura Ingalls Wilder

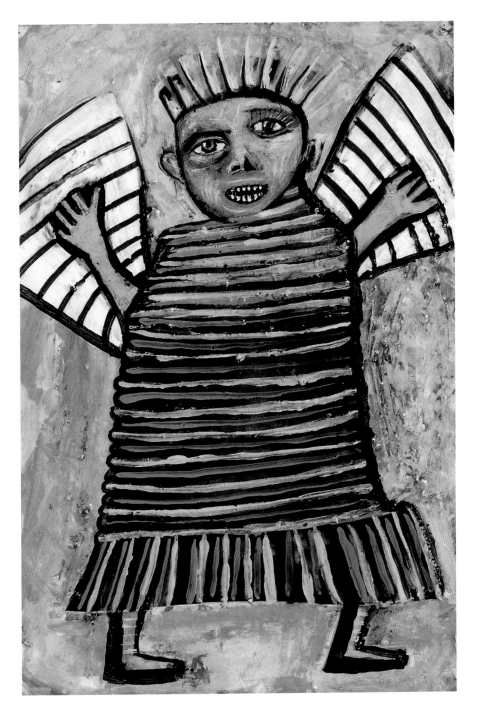

'Twant me,

'twas the Lord.

I always told him,

'I trust to you.

I don't know

where to go

or what to do,

but I expect

you to lead me,'

and He always did.

Harriet Tubman

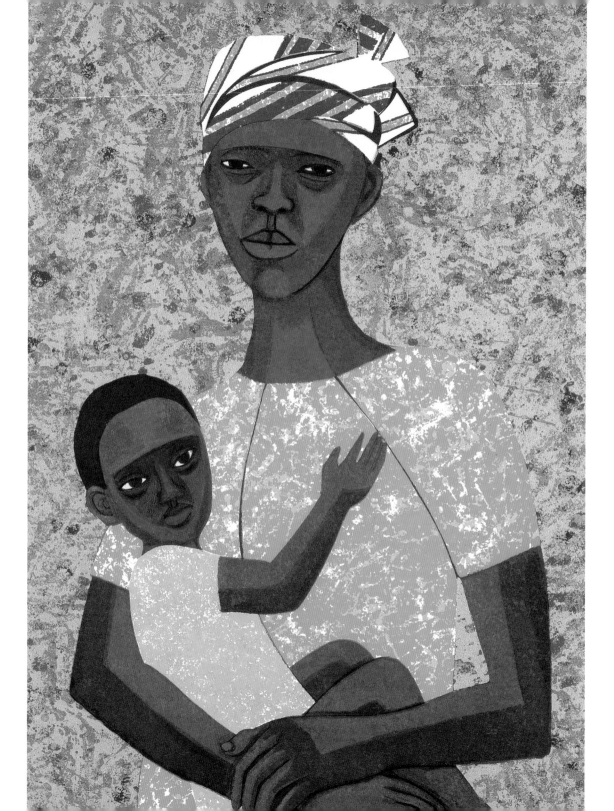

The most **beautiful things** in the **world** cannot be seen or even touched. They must be **felt with the heart.**

Helen Keller

There is so much in the world for us all if we only have the eyes to see it, and the heart and the hand to gather it ourselves...

Lucy Maud Montgomery

That is happiness;

to be dissolved

into something

complete and great.

Willa Cather

If you
obey the
rules
you miss
all the
fun.

Katharine Hepburn

*...your being is full of remembered song!*

*Bernice Lesbia Kenyon*

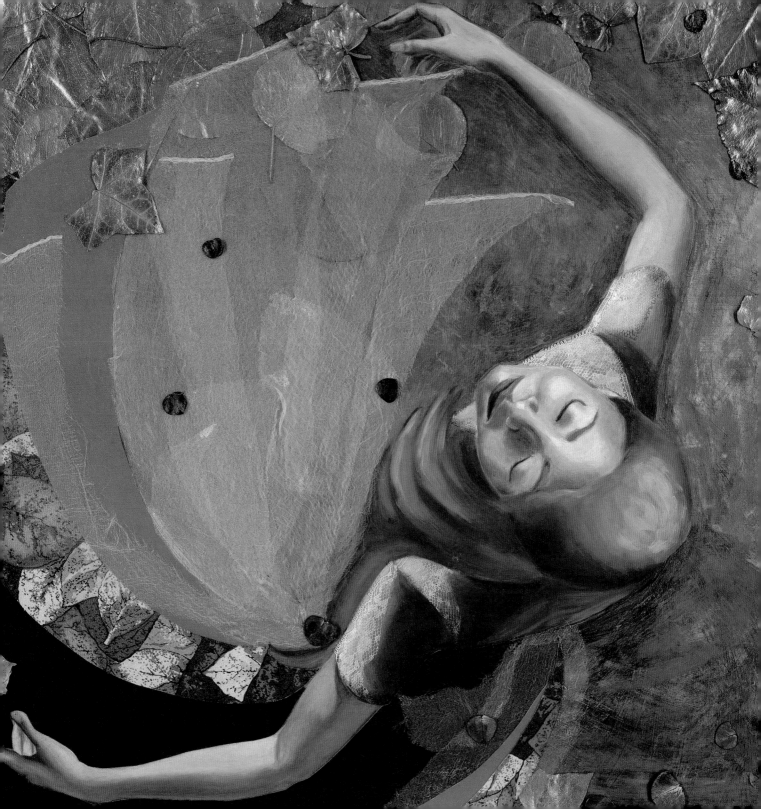

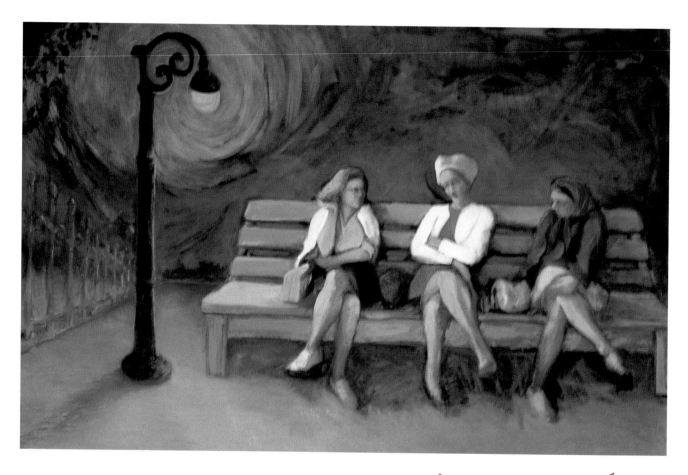

The more you try to be interested

in other people,

the more you find out about yourself.

Thea Astley

Be happy. It's one way of being wise.

Colette

*Taking joy in life is a woman's best cosmetic.*

Rosalind Russell

Joy seems to me a step beyond happiness— happiness is a sort of atmosphere you can live in sometimes when you're lucky. Joy is a light that fills you with hope and faith and love.

Adela Rogers St. Johns

70

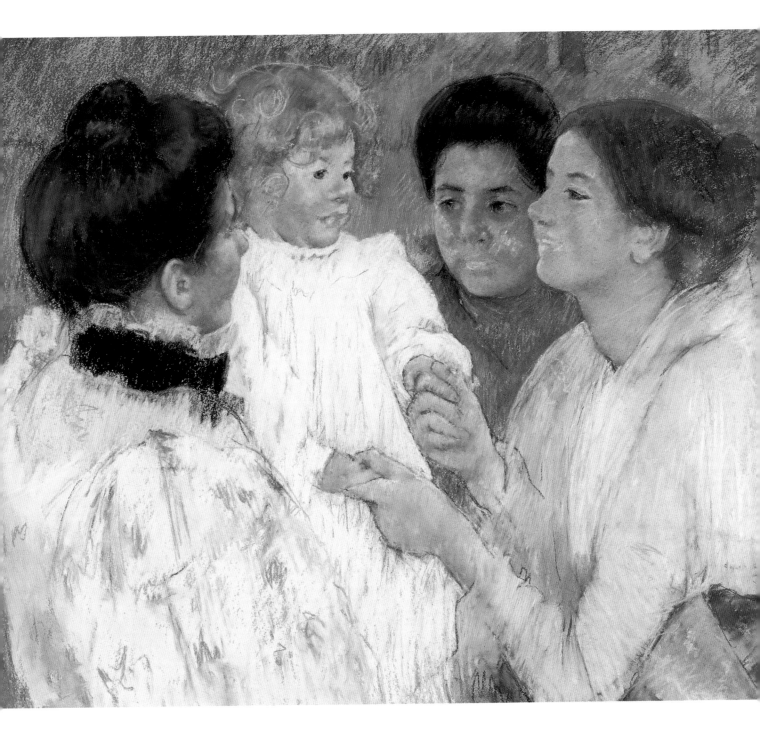

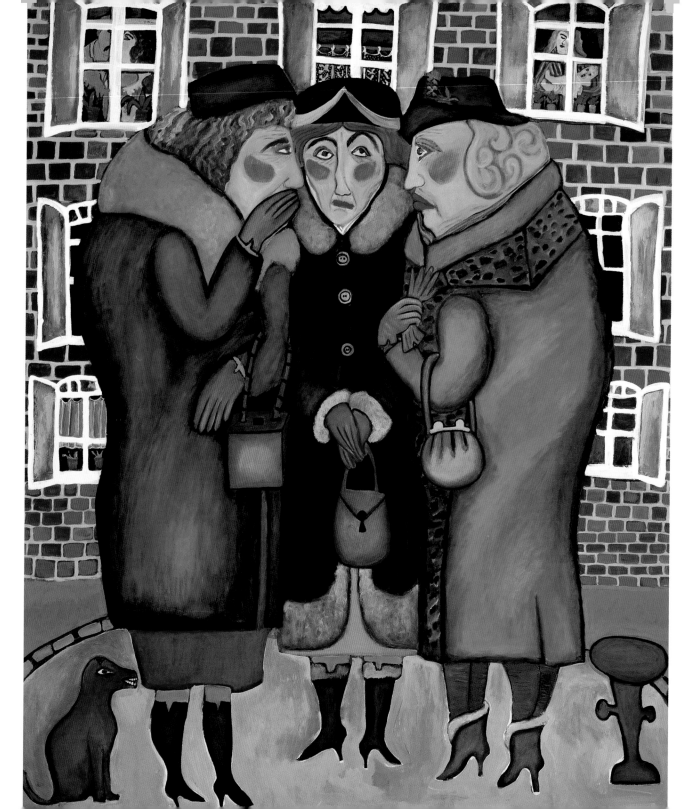

# Maturing

*T*he hardest years in life are those

between ten and seventy.

Helen Hayes

...we get to a certain age, and then the rest of our lives we
do everything we can to get back to the way we were when
we were little...using wisdom to come back to innocence.

Kate Bush

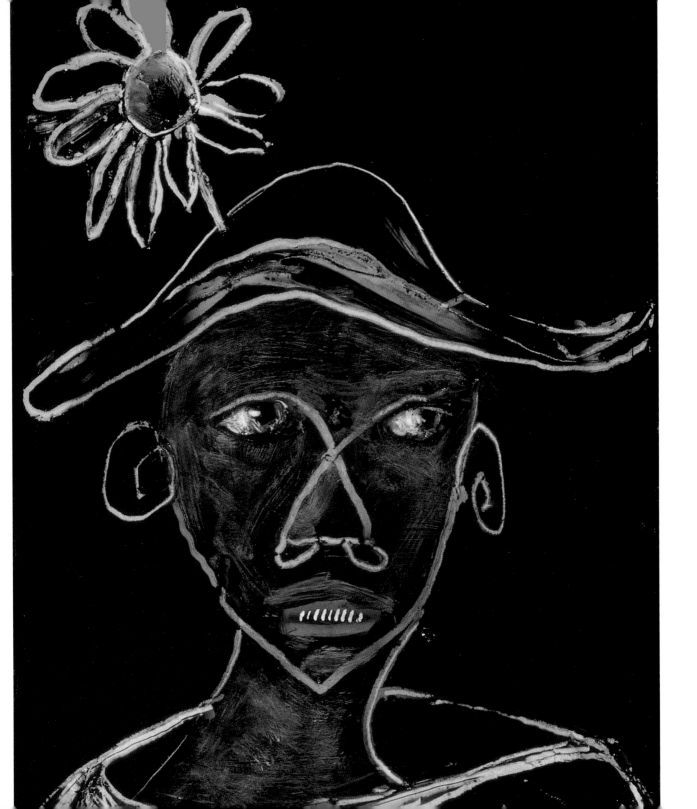

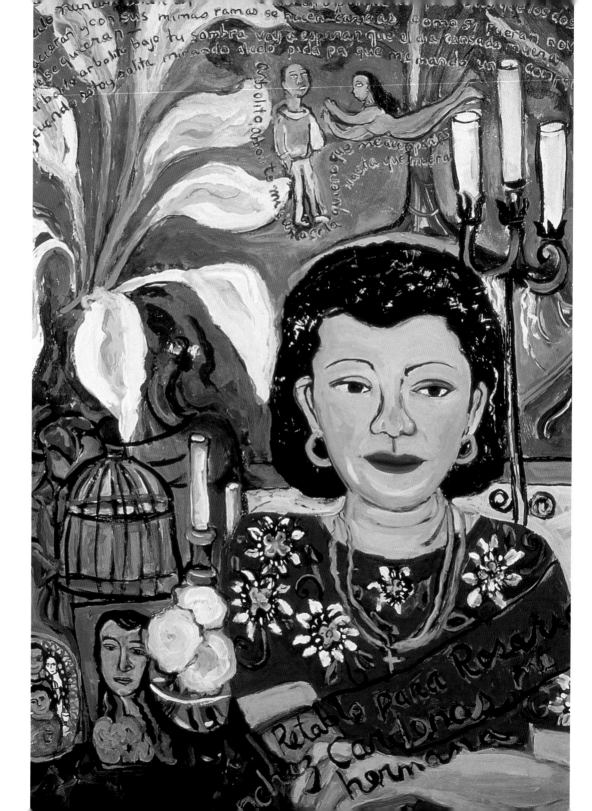

It's **sad** to grow **old,**

but nice to ripen.

Brigitte Bardot

*I* speak the truth,

not so much as I would,

but as much as I dare;

and I dare a little more,

as I grow older.

Catherine Drinker Bowen

*Please don't retouch my wrinkles.*
*It took me so long to earn them.*

Anna Magnani

*You* grow up

the day

you have the

first real

laugh—

at yourself.

Ethel Barrymore

You're
never
too old
to become
younger.

Mae West

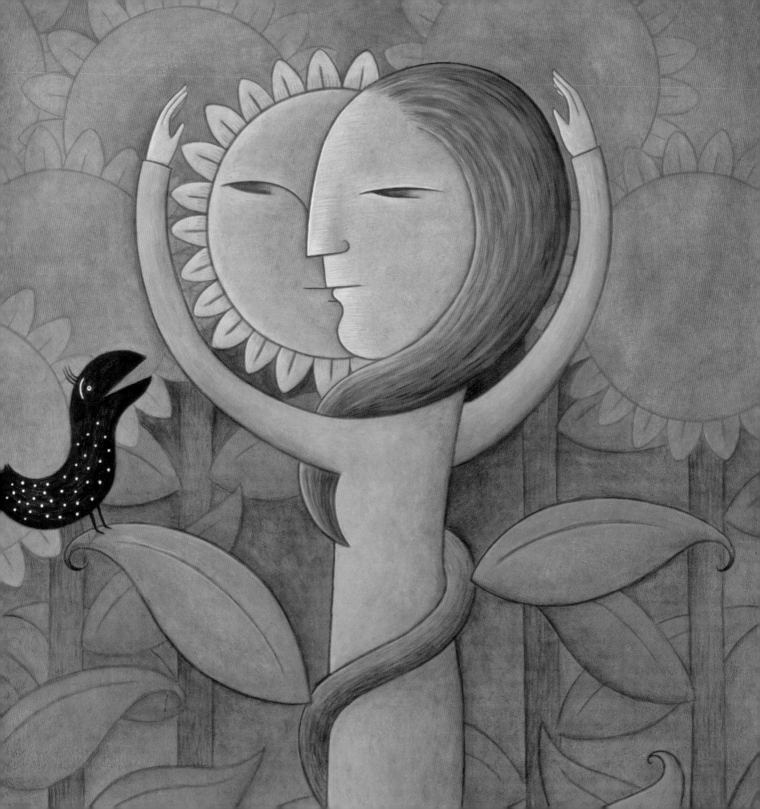

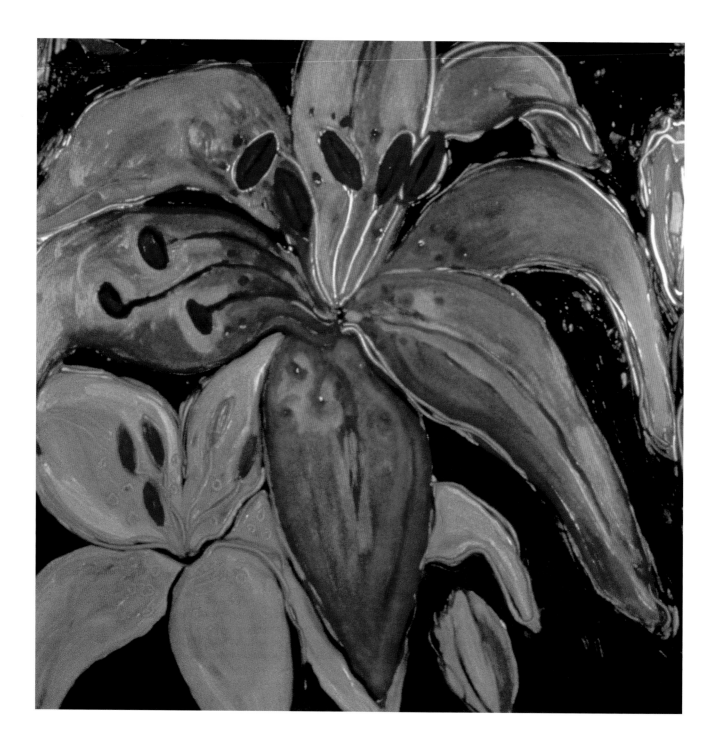

Full maturity...is achieved

by realizing that

you have choices

to make.

Angela Barron McBride

We grow neither better nor worse as we get old,

but more like ourselves.

May Lamberton Becker

One of the many things nobody ever tells you about middle

age is that it's such a nice change from being young.

Dorothy Canfield Fisher

After a certain number of years,
our faces become our biographies.

Cynthia Ozick

*The secret to staying*
*younger is to live honestly,*
*eat slowly, and just*
*not think about your age.*

Lucille Ball

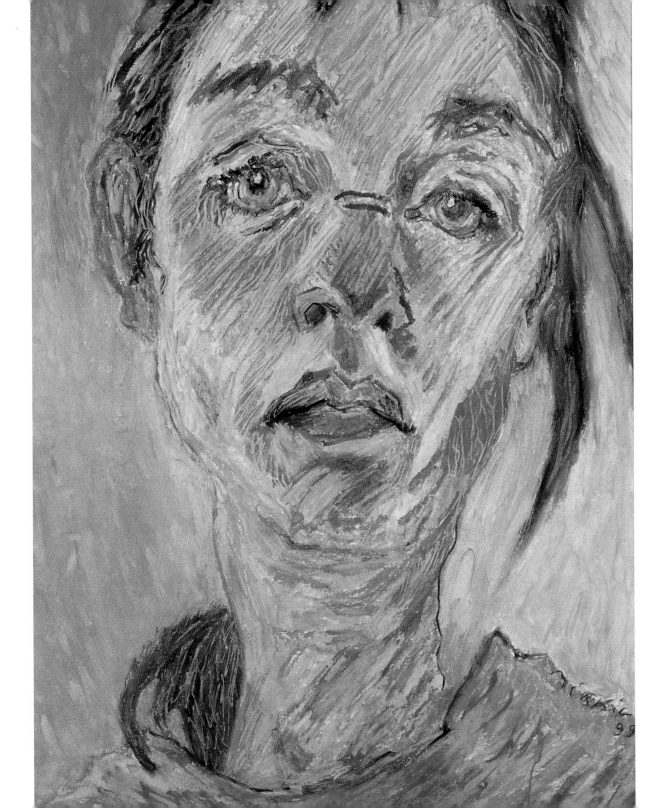

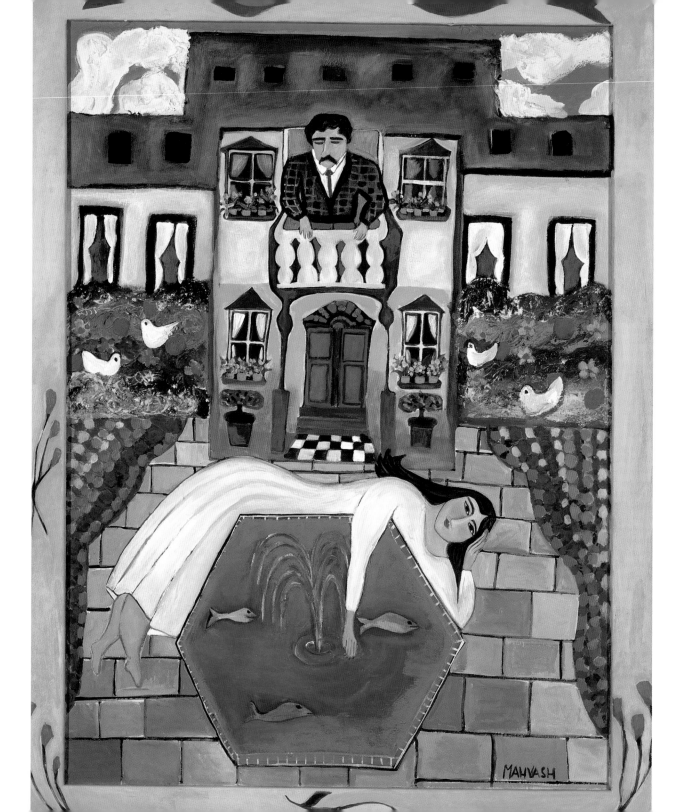

# Dreams and Spirituality

Dreams have only one owner at a time.
That's why *dreamers are lonely.*

Erma Bombeck

If you have made mistakes...there is always
another chance for you...you may have a fresh start any
moment you choose, for this thing we
call 'failure' is not the falling down, but the staying down.

Mary Pickford

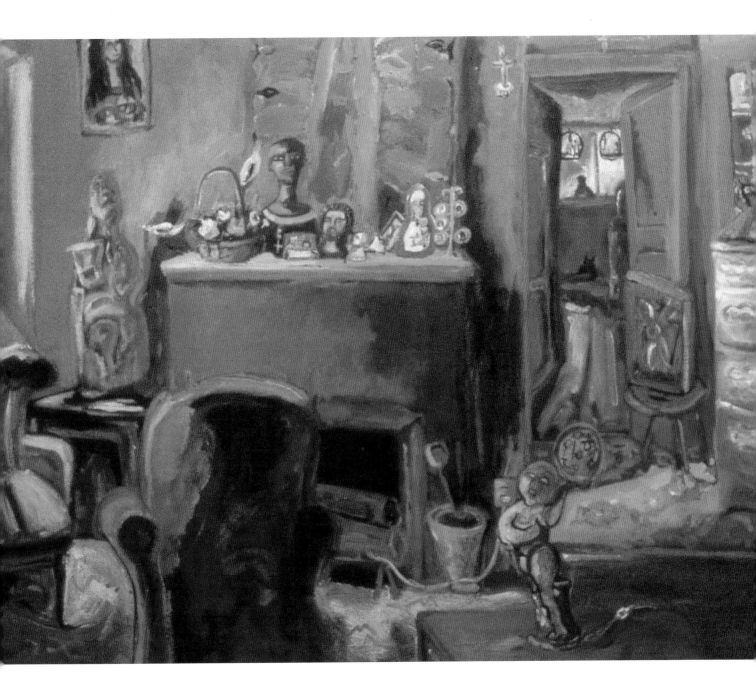

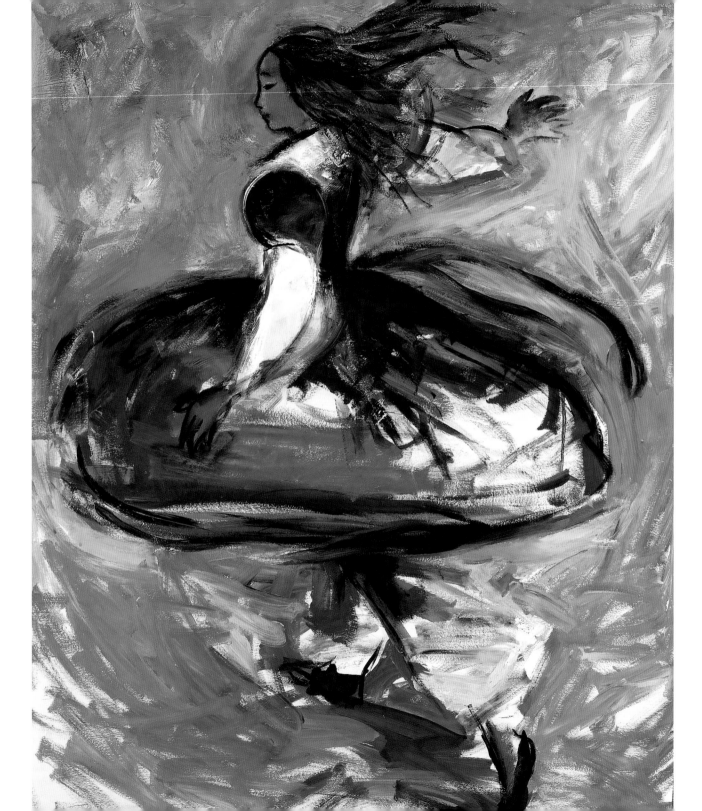

I've dreamt in my life dreams that have stayed with me ever after, and changed my ideas; they've gone through and through me, like wine through water, and altered the color of my mind.

Emily Brontë

The dream was always running ahead of one. To catch up, to live for a moment in unison with it, that was the miracle.

Anaïs Nin

...the soul and the spirit have resources that are astonishing. Like wolves and other creatures, the soul and spirit are able to thrive on very little, and sometimes for a long time on nothing. To me, it is the miracle of miracles that this is so.

Clarissa Pinkola Estes

The future belongs to those who
believe in the beauty of their dreams.

Eleanor Roosevelt

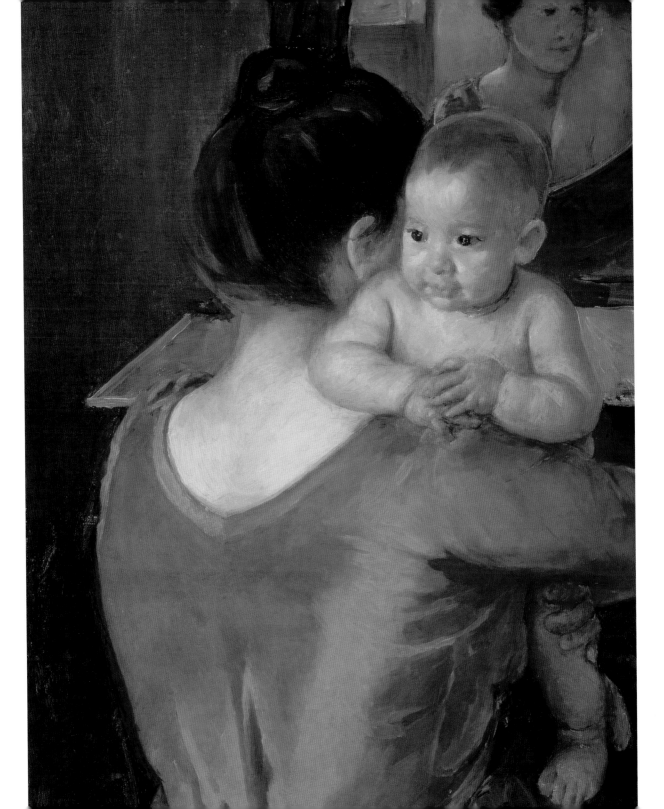

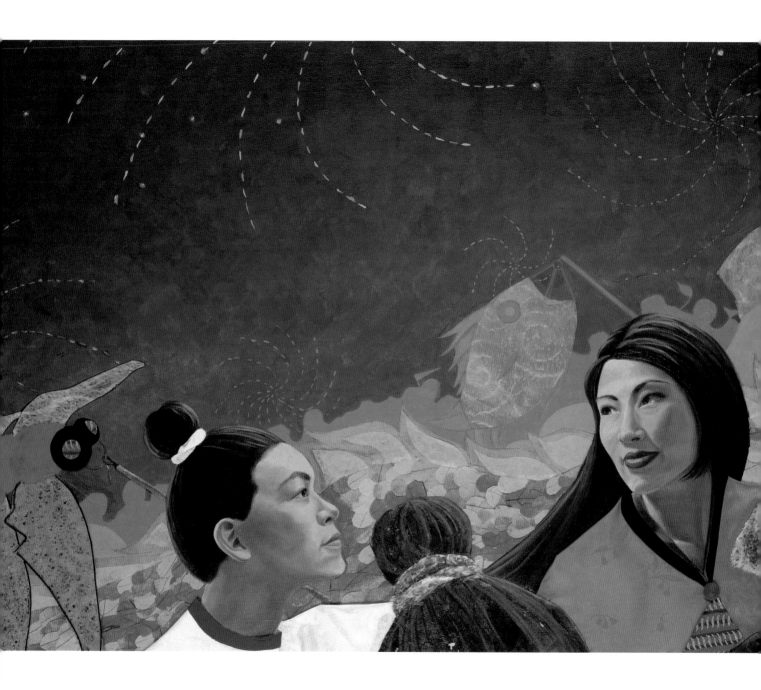

# Reach high,

for stars lie hidden in your soul.

# Dream deep,

for every dream precedes the goal.

Pamela Vaull Starr

...immortality is the passing of a soul through many lives or experiences, and such are truly lived, used, and learned, help on to the next, each growing richer, happier and higher, carrying with it only the real memories of what has gone before...

Louisa May Alcott

It seems to me we can never give up longing and wishing while we are alive. There are certain things we feel to be beautiful and good, and we must hunger for them.

George Eliot

I believe that dreams transport us through the underside of our days, and that if we wish to become acquainted with the dark side of what we are, the signposts are there, waiting for us to translate them.

Gail Godwin

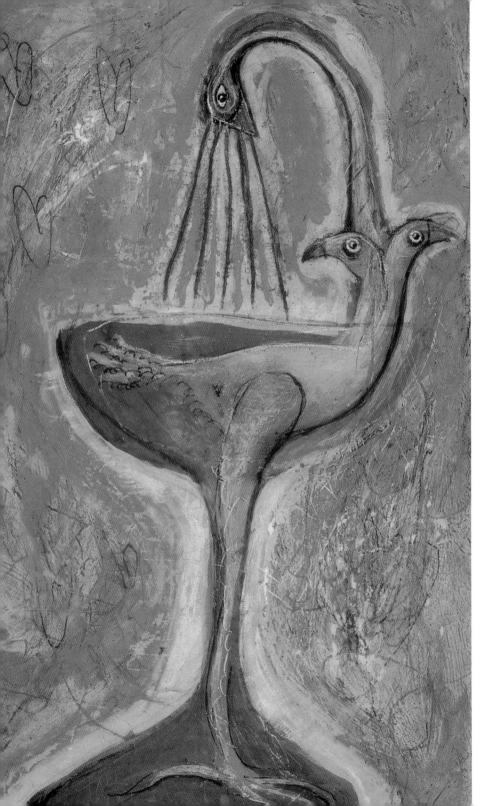

...Dreams

are, by definition,

cursed with

short life spans.

Candice Bergen

# Art Credits

Front cover: Detail from *Until he came to the balcony to call me up* (1997), by Mahvash Mossaed. Courtesy of the artist, www.mahvashmossaed.com.

Back cover: *Butterfly and Flower* (1998), by Christina Hess. Courtesy of the artist, www.chessillustration.com.

p. 6: *Self Portrait with Hat* (1991), by © Michelle Clement/Licensed by VAGA, New York, NY.

p. 8: *Living in a Miniature Doll House* (1997), by Mahvash Mossaed. Courtesy of the artist, www.mahvashmossaed.com.

p. 11: *Blue Dancer* (1996), by Jane Mjolsness. Courtesy of the artist, www.janemjolsness.com.

p. 12: *Moon Maiden* (2000), by Roxana Villa. Courtesy of the artist, www.roxanavilla.com.

p. 15: *Don't Touch* (1996), by Rachel Bliss. Courtesy of the artist.

p. 16: *Yolander* (1998), by Jane Mjolsness. Courtesy of the artist, www.janemjolsness.com.

p. 19: *Sleeping in the Birdland* (1990), by Mahvash Mossaed. Courtesy of the artist, www.mahvashmossaed.com.

p. 20: *Time Pieces* (1998), by Kelly Stribling Sutherland. Courtesy of the artist, www.uponepairofstairs.com.

p. 23: *Rowhouse #21: Wildflowers*. Detail from *9 Rowhouses* (1998), by Amy Orr. Courtesy of the artist.

p. 24: *Spring* (1997), by Rachel Bliss. Private collection.

p. 27: *Girl with Peacock Feathers* (19th century), by Marie Spartali Stillman. The Maas Gallery, London, UK/Bridgeman Art Library.

p. 28: Illustration by © Jacqueline Mair. Courtesy of the artist, www.jacquelinemair.co.uk.

p. 31: *Butterfly and Flower* (1998), by Christina Hess. Courtesy of the artist, www.chessillustration.com.

p. 32: *We built a wall to keep all things not beautiful* (1985), by Mahvash Mossaed. Courtesy of the artist, www.mahvashmossaed.com.

p. 35: *Toomsuba II* (1974), by © Valerie Jaudon/Licensed by VAGA, New York, NY.

p. 37: *Flora* (1894), by Evelyn de Morgan. The De Morgan Foundation, London, UK/Bridgeman Art Library.

p. 38: *Life could not be beautiful all the time* (1998), by Mahvash Mossaed. Courtesy of the artist, www.mahvashmossaed.com.

p. 41: *Glimpses in a window series* (1996), by Patricia M. Siembora. Courtesy of the artist.

p. 42: *Marge's Lupines* (1992), by Emily Brown. Private collection.

p. 44: *Dragon* (1992), by © Idaherma Williams/Licensed by VAGA, New York, NY.

p. 47: *Flower Girls* (1999), by Kelly Stribling Sutherland. Courtesy of the artist, www.uponepairofstairs.com.

p. 48: *Autumn* (1999), by Roxana Villa. Courtesy of the artist, www.roxanavilla.com.

p. 51: *Self-portrait* (1997), by Rachel Bliss. Private collection.

p. 52: *Lustre of Autumn* (1995), by © Diana Kan/Licensed by VAGA, New York, NY.

p. 55: *Woman and Child in a Garden* (c. 1883–4), by Berthe Morisot. National Gallery of Scotland, Edinburgh, Scotland/Bridgeman Art Library.

p. 56: *August Sky* (1999), by Amy Orr. Courtesy of the artist.

p. 58: *Miss Lou 3* (1996), by Rachel Bliss. Private collection.

p. 61: *Tree of Life* (1995), by Carol S. Nowak. Courtesy of the artist.

p. 63: *Angel* (1997), Rachel Bliss. Private collection.

p. 64: *Madonna II* (1991), by © Elizabeth Catlett/Licensed by VAGA, New York, NY.

p. 67: *Yvette* (1998), by Christina Hess. Courtesy of the artist, www.chessillustration.com.

p. 68: *Three Women* (1984), by Rosalind Bloom. Courtesy of the artist, www.rosalindbloom.com.

p. 71: *Women Admiring a Child* (1897), by Mary Cassatt. The Detroit Institute of the Arts, USA/Bridgeman Art Library.

p. 72: *The Gossipers* (1995), by Mahvash Mossaed. Courtesy of the artist, www.mahvashmossaed.com.

p. 75: *Shulane* (1999), by Rachel Bliss. Private collection.

p. 76: *Retablo Para Mi Hermana Rosario Sánchez Cardenas* (1994), by Marta Sánchez. Courtesy of Bill and Kathy Kulik.

p. 79: *Sunflower* (1992), by Roxana Villa. Courtesy of the artist, www.roxanavilla.com.

p. 80: *Daylily* (1996), by Marta Sánchez. Courtesy of the artist, www.artedemarta.com.

p. 83: *Rabbi, I want to see. Mark 10:51* (1999), by Helen Mirkil. Courtesy of the artist.

p. 84: *Until he came to the balcony to call me up* (1997), by Mahvash Mossaed. Courtesy of the artist, www.mahvashmossaed.com.

p. 87: *La Casa de Sra. Muñiz* (1984), by Marta Sánchez. Courtesy of the artist, www.artedmarta.com.

p. 88: *Clara* (1987), by Kelly Stribling Sutherland. Courtesy of the artist, www.uponepairofstairs.com.

p. 91: *Mother and Child* (1900), by Mary Cassatt. Brooklyn Museum of Art, New York, USA/Bridgeman Art Library.

p. 92: *Parade* (2000), by Christina Hess. Courtesy of the artist, www.chessillustration.com.

p. 95: Untitled (1997), by Rachel Bliss. Private collection.